POLITICAL CARTOONS

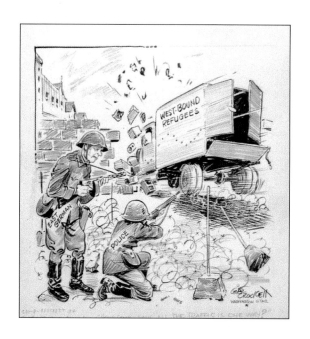

T&J

Published by TAJ Books International LLC 2013
219 Great Lake Drive
Cary, North Carolina, USA
27519

www.tajbooks.com
www.tajminibooks.com

All notations of errors or omissions (author inquiries, permissions)
concerning the content of this book should be addressed to
info@tajbooks.com.

The Publisher wishes to thank all image contributors. The Publisher believes
the use of the cartoons at the size depicted qualifies as fair use under United
States copyright law.
Special thanks to Edward Sorel's caricature of 12 presidents

ISBN 978-1-84406-271-3

Printed in China

1 2 3 4 5 17 16 15 14 13

POLITICAL CARTOONS

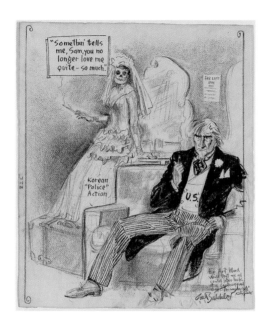

T&J

BY RICK SAPP

POLITICAL CARTOONS

The ancient caves of Europe often contain drawings that depict animals—and people, of course, usually hunting—who long ago passed from among the living.

Professional students have attempted to interpret the cave images from various perspectives. Ritual paintings, say the religious scholars. No, pictures of cultural adventure, say the anthropologists. Perhaps so, but if you look closely at the images, a surprising and wide-spread humor is rampant. Oddly shaped individuals in unusual postures and odd situations chasing or being chased by animals or other partially clothed humans, for example, in Magura Cave in Bulgaria.

Indeed, some of these cave paintings—though extraordinary in many respects—may not be so profound, so timeless, as once believed. Perhaps they exist in the deepest, darkest part of the ancient caves for good reason: they make fun of someone. Perhaps someone powerful. Perhaps rather than being sacred paintings for ancient religious rituals or to ensure the success of the hunt, they are caricatures, the first political cartoons, hidden because they lampoon the leaders, castigate the powerful, and ridicule the rich. Perhaps they tell one of a timeless story—a love triangle or fear of deadly beasts—for that is what political cartoons are all about. Leveling the playing field.

It does not require a free society for political cartoons to flourish, only to become widespread in public. They have always been popular in private, in the parlors and drawing rooms of individual homes, because of the dangers of discovery by the wrong person. It is impossible to imagine someone making fun in public of the Roman Emperor Caligula or Vlad III of Wallachia or Kim Jong-un of North Korea. Spies and informers are everywhere.

Perhaps in ancient days little difference existed between what we now consider graffiti and a political cartoon. In the cities of Pompeii and Herculaneum, though, the graffiti scratched on walls still survives, and much of it is carnal in nature—bragging or ridiculing—rather than overtly political.

In a free society, political cartoons make the reader laugh, or cry, and the very best of them present a point of view about a person, place, or thing of prominence. Queen Elizabeth II of England is lampooned for her funny nose and her crazy family. President Barack Obama of the U.S. receives a great deal of laughter for his big ears and, in some circles, is lampooned because he is black. Guns are pilloried as weapons destructive of the social fabric, but anti-gun advocates are portrayed as naive victims and nut-cases. In a free society, and especially in a free and educated society, everyone's ox eventually gets gored.

Cartoons, especially thoughtful and timely cartoons, that have relevance to current decision making—regardless of the era, modern or medieval—are dangerous because they distort individuals, and the more powerful, saintly, wealthy or well-known the target, the more impact they have

with exaggerated and unflattering features. These caricatures are dangerous to inflexible regimes —nation states or corporations—because they put individuals or situations into the context of shared story lines, exposing their weaknesses and communicating elements of decisions that powerful people usually wish would remain hidden.

A thriving community of political cartoonists requires a modicum of freedom and leisure, but it also takes a society knit together to create a community of interest so that everyone "gets the joke" and shares in the ironic twist suggested by the cartoonist.

The development of the earliest printing presses allowed cartoonists to flourish, but the real rise of cartooning had to wait for the movable type and photographic plates of the modern era. An artist could scratch an inflammatory image on a city wall, but even in the busiest city it will be little noticed and can easily be scratched out or painted over.

Other than the cavern walls of the world, political cartooning probably began as caricature in southern Europe with one target being exaggerated images of popes with warty noses; popes in those days were powerful political actors as well as the mouthpiece of God. Caricatures of popes were in high demand, at least until the Inquisition came calling. Some credit Leonardo da Vinci's vigorous drawings and immense curiosity about the human form with sparking this nascent artistic genre, but surely he is only the most well-known rider on the crest of the Renaissance wave.

While the south of Europe gasped for air beneath the seat of the Christian church, northern Europe was throwing off the shackles of constrained thought and action. The Protestant Reformation is credited with more than simply opening the minds of the religiously inclined; it opened the imagination. In addition, and although progress was uneven, a prosperous merchant class in northern Europe was gaining political strength co-equal with the church and the nobility. Indeed, at the time, even many of the nobility were illiterate, and the clergy understood only the approved sacred texts. The merchant class could afford to enjoy and sometimes to hire the talents of artists, woodcutters, and metal engravers.

Christian reformer Martin Luther encouraged the distribution of simple broadsheet posters or illustrated pamphlets in the population centers of north Germany in order to present his argument and beliefs within the context of the understanding and daily experience of the people who would read them. This proved to be an effective strategy for reaching those in the illiterate (but not unintelligent) masses.

Luther's illustrators for example, contrasted sacred images of Jesus with those of the official church hierarchy in a pamphlet called *Passional Christi und Antichristi*, originally drawn by Lucas Cranach the Elder. The images contrasted the actions of Jesus with those of the church hierarchy. Luther understood that illiterate people, raised with a deep faith in scripture, would immediately understand the juxtaposition of sacred versus profane images. The

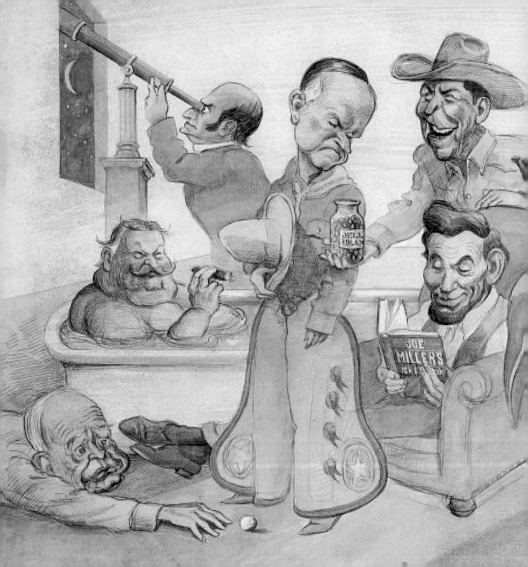

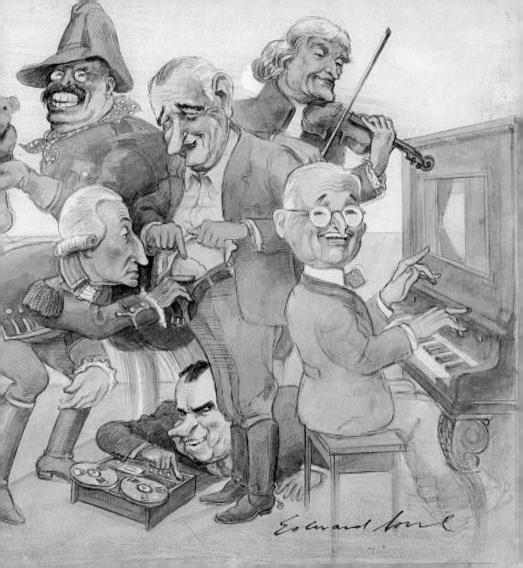

suggestion, made within the context of a Biblical story, was that the official church was deeply corrupt, and people who saw the images responded emotionally.

Eventually the northern and southern styles of cartoons merged: the artful, even grotesque, caricature merged with the story line popular in the north. It is easy to see where this was leading. Monarchs, scholars, generals, and artists were all pilloried in the evolving cartoons, and for the next 500 years, the tools and the medium underwent amazing changes. The idea, however, that the rich and powerful were appropriate subjects for cartoons has remained a permanent fixture in Western thought.

America was settled, at least in part, on political dissent. Only the rich and well connected could hire ships, recruit passengers, and pay for their upkeep until the colonies became self-sustaining. The ships however—at least those from Northern Europe; France and Spain tended to keep malcontents at home—were filled with people for whom the Old World had become economically and socially intolerable. America immediately became a hot bed of new and rebellious ideas. The political cartoon, poking fun at "one's betters," was a primary method of expression.

Despite their shared burden of toil and fear, the European colonists did not find a land of milk and honey in the New World. Life was hard and the original residents of settled areas were not overly delighted at being displaced. This ultimately led to a drawing by a Philadelphia printer named Benjamin Franklin who succinctly expressed the Americans' fear of the Indians with a sketch titled "Join or Die."

Franklin, like da Vinci, before him, was considered a polymath, a man of many talents possessing a mind that teemed with questions and experiments. Ultimately he became a writer and natural scientist—among other things—but it was in this respect, as a man with a wide following among the people of Philadelphia, that the woodcut "Join or Die" struck a deep chord.

The 1757 woodcut "Join or Die" depicted a snake and each segment of the snake was labeled with an American colony's abbreviation. The snake image drew on popular superstition that a dead snake could come back to life, even if it were chopped into pieces, if the pieces were reassembled and placed next to each other. Alone, Franklin seemed to be saying, the colonies might survive, but as one unit they were greater than the sum of the parts;

he saw the value of unity against the Indians and their French allies in pre-revolutionary America. The cartoon took on a life of its own, quickly becoming a symbol for all Americans who believed they had a complaint against Great Britain. Widely reprinted, the disjointed snake became an icon of the revolution, an odd but enduring symbol of unity, because it conveyed a simple message that everyone could understand and it helped carry America to independence.

In a republic that prized independence of spirit and the freedom to speak one's mind, at least for white men, it is inevitable that political cartooning evolved rapidly from Franklin's simple woodcut of a disjointed snake.

Other patriots joined Franklin. Woodcuts of the era became more sophisticated and more pointed in their meaning. The messages were labor intensive and expensive because they required both time and multiple skilled craftsmen. For example, an artist could make a sketch on paper and attach the paper to a block of wood to give the cutter a template: the "white" or nonblackened areas were cut out of the wood leaving the "black" areas to take the ink and thus press an image on a newspaper sheet.

A hard wood was difficult to work, but a softer wood gave a poorer image and would not last for continual printing. In Europe, fruitwood such as pear or cherry was commonly used; the Japanese preferred cherry. Sometimes the image was drawn directly onto the wood. In making an image, the art would be destroyed and the eventual printed

image might only approximate the artist's concept, depending on the skill or whim of the cutter. Thus newspapers of the era have few illustrations and relatively few woodcuts of that time survive, most having been discarded after use.

Political cartoons played a central role in spreading information or gossip, even outright slander, because in the budding United States of America few restraints, other than access to a printing press, inhibited the message. Boston silversmith Paul Revere even tried a hand, successfully, at molding mass sentiment by way of political engravings.

Revere's work, modeled on a drawing by Henry Pelham, was colored and printed by others, but his "The Bloody Massacre" political cartoon stirred anti-British outrage throughout the colonies. Supported by multiple reasons to be disgruntled with distant rule, such as having little or no voice in one's own taxation or political affairs, cartoons were pivotal in developing the communal will to fight for independence. They fanned the flames of discontent. Revere's cartoon was not a statement of policy but perpetuated a view of Great Britain as powerful, imperious, and arrogant that proponents of revolution desired. The cartoon swayed many opinions and inflamed the common desire to fight for independence. The rest, as they say, is history.

As printing and metal engraving methods became more sophisticated, cartooning in the new republic flowered, developing a mean streak, even toward George Washington, the savior of

the fledgling nation. Every president in America's history has been pilloried by opposing parties and the cartoonists who work for them. Thomas Jefferson felt the scorn of opponents when he made the Louisiana Purchase, surely the best international commercial contract ever conducted by the office of the president. Jefferson was depicted as a madman, a drunkard, in league with the devil, and as a prairie dog barfing money into the coffers of Napoleon Bonaparte. Some invective was due to Jefferson's commercial policies which were credited with practically bankrupting the new nation.

Prior to the U.S. Civil War, however, few presidents received the public flogging offered to Andrew Jackson. A proud man, a patriot, a general and successful Indian fighter, in an era when that was an honorable profession, Jackson's dual nature got him into trouble. He was a man of the people, but he could also be haughty and overbearing. Like U.S. Grant 40 years later, Jackson also had to cope with financial corruption in his administration, and many of his appointments were forced to resign in disgrace.

Like other senior elected officials, Jackson made liberal use of his powers of appointment. When he fired dozens of federal employees to make room for his men, he was demonized in print and in political cartoons as a monarch, sometimes as a king regally astride a pig.

The 1800s were heady days of the spoils system, and recently elected politicians—from city councilmen to presidents—made liberal use of the public coffers to reward their supporters. In political cartoons, Jackson was accused of fraud, bribery, and simple thievery. After his veto of the bill to create the Bank of the United States, an institution he hated because it rewarded individuals who did not support him and because he feared it would have harmful effects on America's poor, Jackson's opponents accused him of abusing his presidential powers; newspapers of the day depicted him as a tyrant, trampling on the U.S. Constitution.

Political cartooning evolved in style as the Civil War rolled toward its opening shot, and etched-plate cartoons proved that they could both ridicule and honor. A famous engraving that appeared following the Mexican-American War of 1846-48, for instance, lionized U.S. General Zachary Taylor. In the image, a bald eagle carries a bolt of lightning in one talon and an olive branch in the other. Beneath it, large, internally illustrated letters resplendent with olive branches and American flags, portray the name "Taylor" with the names of famous battles, and tiny battle statistics within the letters. The cartoon promotes Taylor's prowess and, through him, that of America itself.

By the time the Civil War erupted over Fort Sumter in the harbor of Charleston, South Carolina, political cartooning had reached such a height of vitriol that, by today's standards, many published illustrations would be unprintable even as "visual satire." Lincoln, known heroically in Republican circles as "The Rail Splitter," was lampooned as a country bumpkin, a fool, a lout; cartoons showed

his head impaled on split rails. Northern General U.S. Grant was subjected to illustrations of him as a butcher, even a traitor. Black Americans were derided as "Sambo" and monkeys, and women who sought equal rights were publicly ridiculed and defamed. Cartoons in Northern magazines tossed blame to all quarters likening Confederate President Jefferson Davis as a petty thief and liar, stealing Federal property even as he claimed that all he wanted was to be left alone by the Federal government.

The German-American immigrant Thomas Nast is considered to be the "father of the political cartoon." Nast got his start in the Civil War. The cartoons of the latter half of the 19th century seem antique, even monstrous, by today's standards, but the graft and corruption of the day were themselves grotesque. And so after the war, Nast turned his talented hand to politics while working for the popular *Harper's Weekly*. In particular, with the magazine's approval, he began to lampoon William Tweed, called "Boss" Tweed in New York City where his gang milked the city of millions of dollars, equivalent to a billion or so in today's dollars.

At one time it was believed that Nast's cartoons were instrumental in Tweed's downfall and the return of the city to, if not honest and accountable government, a ruling elite that stole less obviously. Tweed fled the country and was captured in Spain when police—acting on a warrant from the U.S.—recognized him from a Nast cartoon. He died in a New York City jail.

Revisionist history says Nast's political cartoons, while important in raising the consciousness of the populace, have been over-emphasized in the clean-government fight, yet they still highlight the cartoonist's ability to develop caricature in a relevant situation and to arouse popular indignation. Thus, Nast was a seminal figure in the evolution of the political cartoon. He eventually took on the Roman Catholic Church, powerful because of New York's massive immigrant population, and the Ku Klux Klan, which had branches in every state. His cartoons frequently had numerous sidebars and panels with intricate subplots related to the main cartoon. It was observed that a Sunday feature could provide hours of entertainment. Nast's rough-and-tumble cartoons, even appearing on the cover of *Harper's Weekly*, gave the cartoonist a standing and a following.

Nast also used his artistry to convey scenery, such as the ruined cities of the South in the aftermath of the Civil War, but the growing capabilities of photography narrowed the requirements for cartooning. The craft that Nast practiced took hold of the American imagination and when people began to demand cartoons from other publications, the craft became a true profession.

As Nast's cartoons receded from the public imagination, other artists stepped into the positions that Nast had almost single-handedly summoned forth by his pursuit of Boss Tweed's Tammany Gang. Many of the subsequent cartoonists were European in origin, such as the more elegantly productive Joseph Keppler, a crusading social activist, who

was called the "most commercially and critically acclaimed cartoonist of the Gilded Age." Keppler's most potent tool was not the iron hammer of Nast, but the iron fist inside the velvet glove of humor—and this trajectory instilled new life into the political cartoon.

Making fun of the rich and the powerful, of America's unabashed system of political corruption called "the spoils system," suddenly became popular. National administrations from those of Ulysses Grant to Teddy Roosevelt, and the political machines they often represented, were subjected to the reformist wrath and the illustrated humor of cartoonists. Poking fun up the social and political ladder has never stopped.

Whether the 20th century was the bloodiest century of human history or not is debatable, but that century began—at least in the public imagination with either the sinking of the Titanic or World War I—and ended on 9/11. Between the symbolic beginnings and endings of the century, there was plenty to cartoon about: wars, nuclear weapons, great depressions, plagues, and the exploration of space. The staple however remained the basic human foibles: greed and elementary inhumanity.

In the 20th century, the cartoon came of age. It rode the wave of newspaper and magazine printing, but abdicated its front page presence to photography and moving to the editorial page. By the end of the century it also shared the weakness of the print medium as cartoonists struggled with the decline of

paper and the rise of electronic communication.

With the advent of Muslim fundamentalism, political cartoonists also found themselves subject to religious bigotry and persecution, losing their ability to speak freely—cartooning in the U.S. is considered speech—because of in-bred cultural ignorance. Indeed, since the murder of Dutch film director Theo van Gogh in 2004 on the streets of Amsterdam, artists and cartoonists have become increasingly aware of their vulnerability. Danish cartoonist Kurt Westergaard still remains under police protection following a 2008 cartoon depicting the prophet Mohammed with a bomb in his turban.

In some publications, the small "pocket" cartoon became popular. A pocket cartoon is typically a single-panel, single-column drawing, almost a sketch with an abbreviated and pointed message. Pocket cartoons are still popular because they break up columns of type and direct humor (or abuse) to particular incidents or examples rather than to the story as a whole.

Cartoons also adapted to the clothing and rhetorical styles of the day. The sketches drawn by U.S. servicemen in the 1940s often featured a character named Kilroy peeking over a wall with the phrase "Kilroy was here." It became a symbol of shared levity in an otherwise long and almost unendurable conflict. Bill Mauldin's black-and-white cartoons featuring U.S. GIs Willie and Joe brought that war home to Americans who were otherwise insulated by oceans on either side of the continent. In the same manner, the "Keep on Truckin'" cartoon

by Robert Crumb came to symbolize the counter-culture and anti-war movement of the 1970s.

In the latter half of the century, politics invaded the classic "funny pages." It was sometimes difficult to distinguish the line between a sketch meant to be funny and one of political commentary. Comic strips, such as Milton Caniff's "Terry and the Pirates," placed heroic Americans on an international stage in the 1930s and 1940s, while strips dealing with domestic affairs, such as "Dick Tracy," infused classic police work with elements of cultural satire. Artist Chester Gould, the creator of "Dick Tracy," drew most of his villains with some physical handicap.

Of course, all this led to the most popular and enduring cartoon of the last half-century, Garry Trudeau's "Doonesbury." Since its original publication in 1970, Trudeau has given readers and publishers fits deciding whether the cartoon, which is clearly political commentary, should be placed on the editorial and opinion pages or with other newspaper comics, most of which deal with the humor and irony implicit in our family (Lynn Johnston's "For Better or Worse"), work (Scott Adams' "Dilbert"), and personal (Greg Evans' "Luann") lives.

Political cartooning is either a dying occupation or a wide-open and growing field, depending on point of view. Although print has declined steadily, political cartooning has not disappeared. The Internet delivers content and commentary instantaneously, and as newspapers, journals, books, and popular magazines make the transition to electronic publishing, the medium has already begun to change. Far from destroying the political cartoon, the Internet has opened access for millions, perhaps billions around the world. No longer must readers wait for a newspaper to arrive on the front drive or the magazine to be delivered by mail; information is available at the touch of a finger. Anyone "surfing the net" can find cartoons about North Korea's nuclear-armed and belligerent leader side-by-side with cartoons about the resignation of a local politician caught in a sex scandal.

Web logs or "blogs" have given countless aspiring cartoonists the opportunity to publish sketches and personal opinions. The salvation of the political cartoon, "where the pen meets the sword," may rest in its international acceptance as both an art and a means of educating and stirring public opinion. Cartoonists rarely suffer fools in politics or religion or in popular culture and are always among the first to notice that "the emperor has no clothes."

Indeed, dozens of high-quality commentators standing on the shoulders of Pulitzer Prize winners and internationally recognized cartoonists such as Herbert Block now use the political cartoon to shape public opinion. Because these images are widespread on the Internet, they are more powerful than ever. Cartoonists such as the Americans Steve Breen, Chris Britt, Mike Luckovich, Ben Sargent, and others around the world are carving out a future for political cartooning that the earliest cave artists would appreciate.

Plate 1

BURSTING THE BALLOON

1844

Democratic frustrations in the race for the "Presidential Chair"

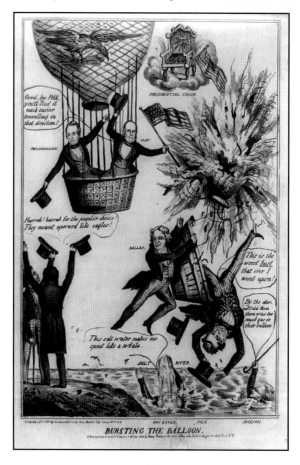

Plate 2

ANDREW JOHNSON AND ABRAHAM LINCOLN

1865

Vice President Andrew Johnson and President Abraham Lincoln attempt to fix the Union.

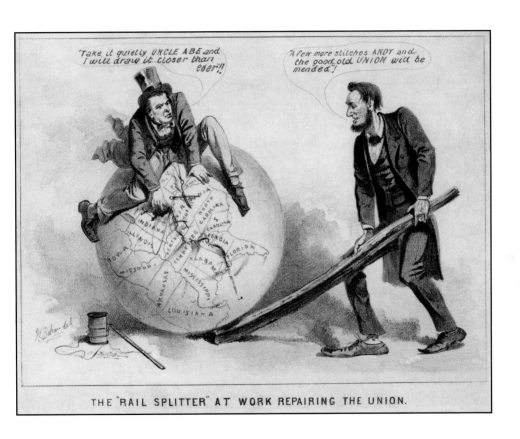

THE "RAIL SPLITTER" AT WORK REPAIRING THE UNION.

Plate 3

PRESIDENT ANDREW JOHNSON'S AMBITIONS
1867

*This Thomas Nast cartoon mocks Johnson for royalist ambitions and for causing the July 1866
race riots in New Orleans in which many African American delegates to a Radical Republicans
conference were killed by police.*

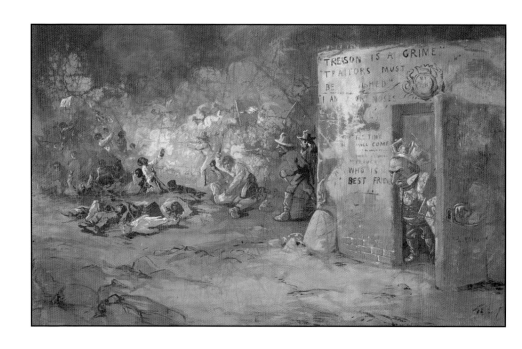

HAVE A BEER, NEIGHBOR
1871
With the Treaty of Versailles ending the Franco-Prussian War, the decline of France's position in Europe was obvious.

Plate 4

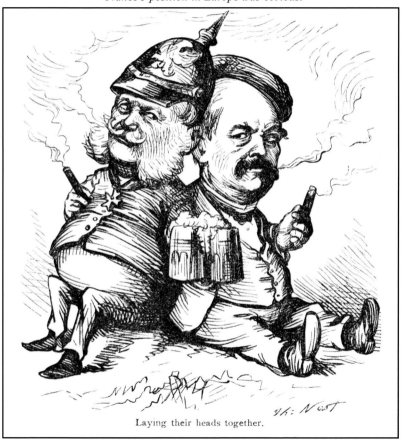

Laying their heads together.

Plate 5

PRESIDENT GARFIELD'S INAUGURATION
1881

The special interests and supporters that paved Garfield's path to the White House

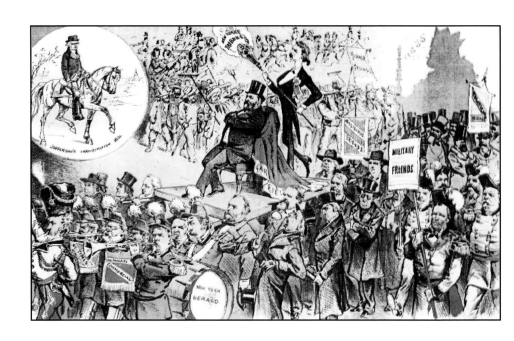

Plate 6

BROKEN BANKS—WHO IS RESPONSIBLE?

1881
Puck, the personification of the magazine, implicates the entire
banking industry in the Newark Bank Swindle.

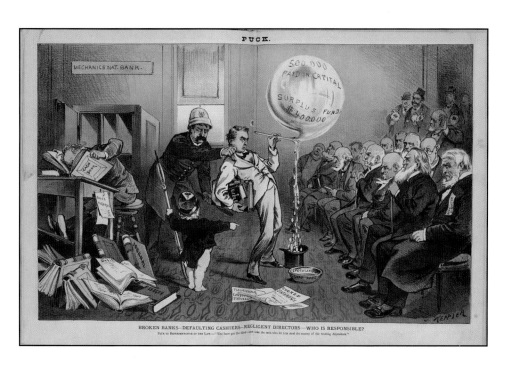

Plate 7

BUSTED

1884

Fredericka Mandelbaum, a notorious fencer of stolen property in the 13th Ward of New York City, was in cahoots with local police.

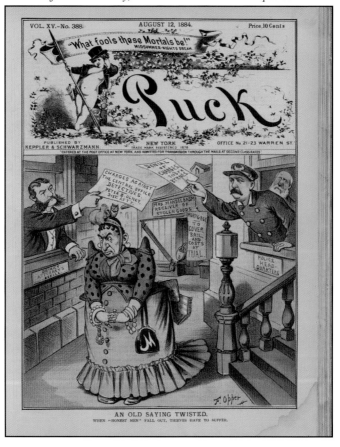

Plate 8

HUSH MONEY

1884
Rampant polical corruption

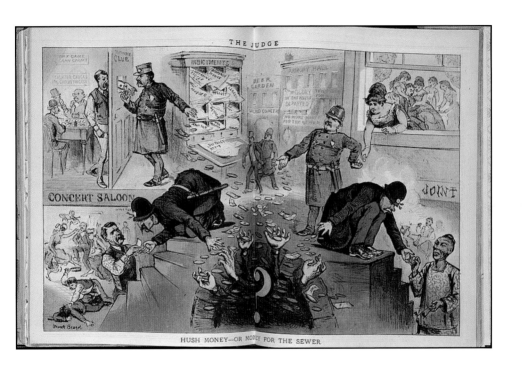

Plate 9

NOISE OR NOTHING!
1884
Free speech from the pulpit is not always welcomed.

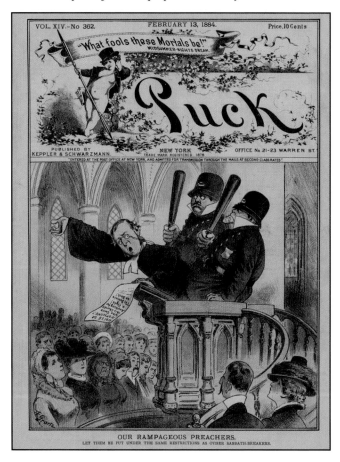

TO BEGIN WITH, I'LL PAINT THE TOWN RED

Plate 10

1885

The Judge *magazine depicts democracy as the devil whose paintbrush is a profile caricature of President Grover Cleveland; some government buildings fly red flags for war debt and pension debt.*

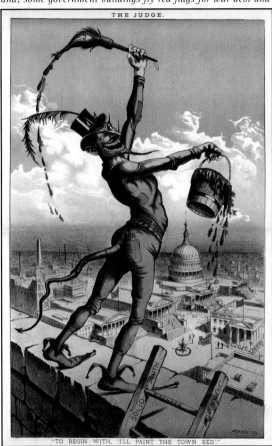

THE JUDGE.

"TO BEGIN WITH, 'I'LL PAINT THE TOWN RED'."

Plate 11

MAYOR ABRAM HEWITT

1887

Public complaints about police brutality and corruption in New York City

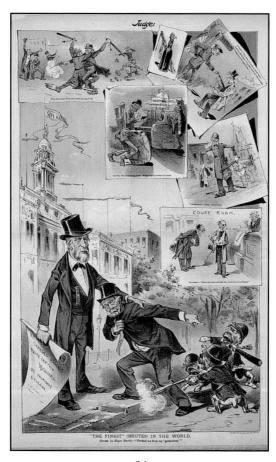

Plate 12

NEW KIND OF POLICY SHOP

1888

Voters' discontent with incumbent President Grover Cleveland's policies are represented by the spatoon on the floor; Cleveland lost re-election.

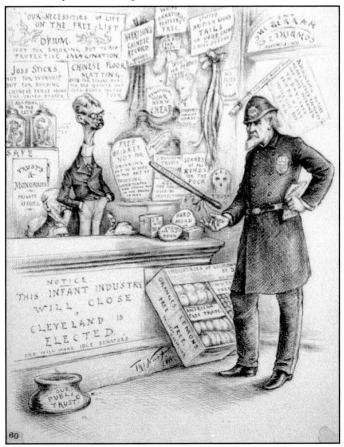

Plate 13

MULBERRY RING GROWING FAT

1892

Bulldog in the uniform of the NYC police department
located on Mulberry Street and notorious for corruption

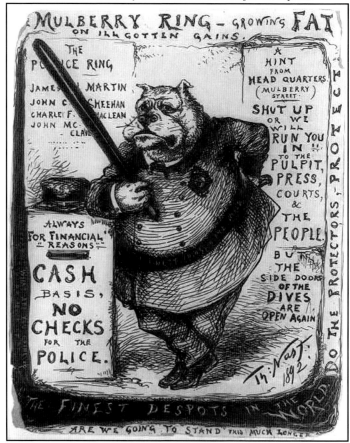

WANGTOWN BUGLE

1895

Originally published in Harper's Bazaar, *the cartoon depicts heavy-handed police tactics in support of corrupt practices.*

Plate 14

Plate 15

ATTACKING HIM IN BROAD DAYLIGHT

1897

Frank Black, governor of New York, and Charles Grosvenor, a U.S. representative from Ohio, attacking Civil Service reform

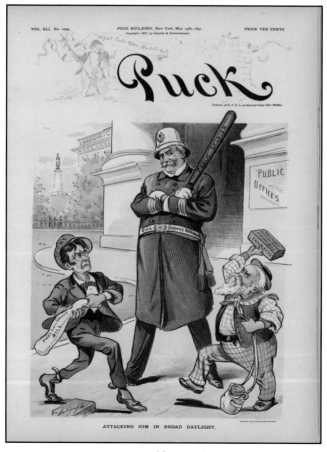

Plate 16

D.C., I'VE GOT SOME HOUSCLEANING TO DO

1898

U.S. House of Representatives mid-term elections in which President McKinley's Republican party lost seats but maintained a majority

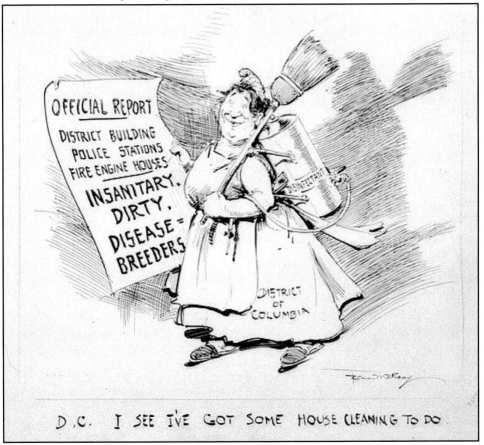

Plate 17

A NEW YEAR

1899

*Puck encouraging N.Y. Governor Theodore Roosevelt to follow through on
civil service and police reform, among other issues of the day*

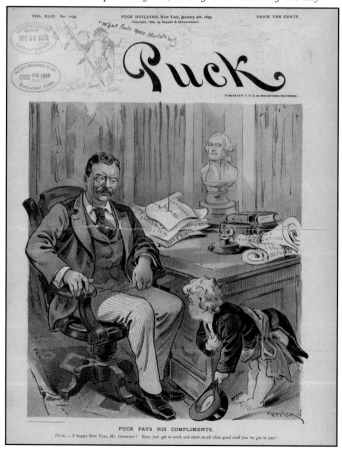

PUCK PAYS HIS COMPLIMENTS.

PUCK.— A happy New Year, Mr. Governor! Now, just get to work and show us all what good stuff you 've got in you!

A HEAVY HAND
1899
Vice President Teddy Roosevelt's fierce approach to police reform

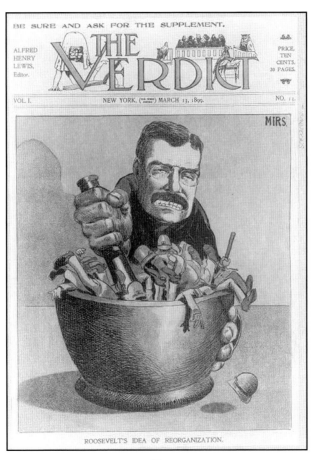

Plate 19

THE MOTE IN OUR NEIGHBOR'S EYE

1899

Calling on the U.S. government to regulate "brutal and degrading" sports

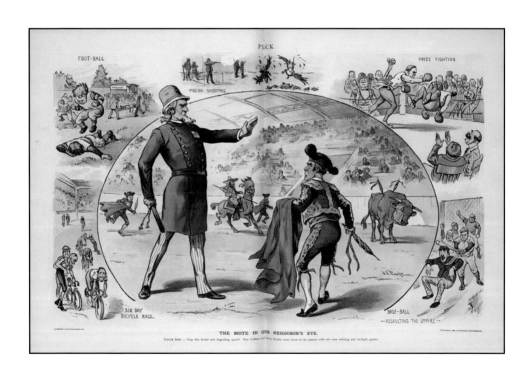

THE MOTE IN OUR NEIGHBOR'S EYE.

UNCLE SAM. — Stop this brutal and degrading sport! You Cubans and Porto Ricans must learn to be content with our own refining and civilized sports!

Plate 20

THE WHEEL THAT CAN'T BE STOPPED: HUMAN NATURE

1901

Even reformers cannot stop the influence of human nature, which incites gambling

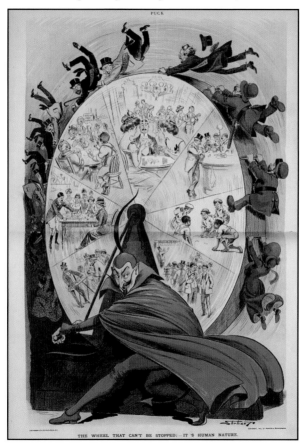

THE WHEEL THAT CAN'T BE STOPPED: — IT'S HUMAN NATURE.

Plate 21

FIGHT FOR A SENSIBLE SUNDAY LAW

1901

Father Knickerbocker, a symbolic figure of New York City, fighting hayseed legislation and temperance fanatics with tolerance and common sense

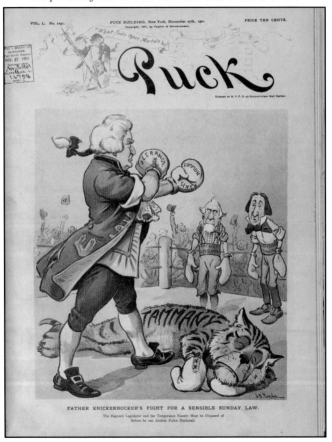

FATHER KNICKERBOCKER'S FIGHT FOR A SENSIBLE SUNDAY LAW.

The Hayseed Legislator and the Temperance Fanatic Must be Disposed of Before he can Abolish Police Blackmail.

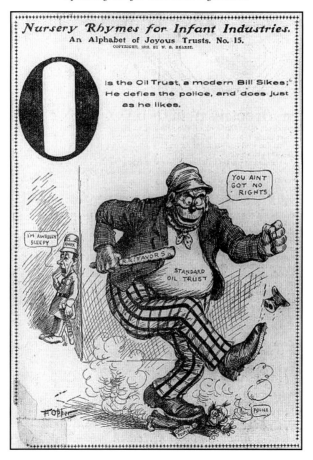

Plate 23

A NEEDED CHANGE IN THE SENATORIAL LOBBY

1902

Speaking out against wholesale lobbying of U.S. Senators

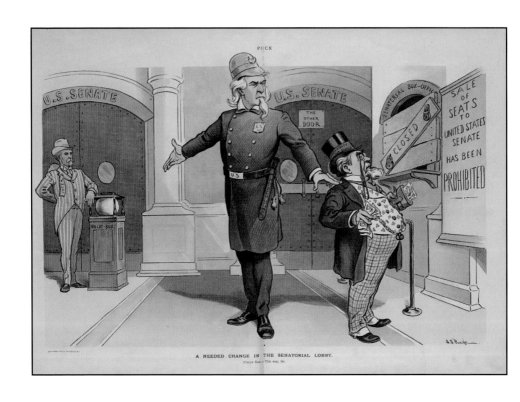

A NEEDED CHANGE IN THE SENATORIAL LOBBY.

Uncle Sam.— This way, Sir.

Plate 24

IN THE COURT OF PUBLIC OPINION

1903

Uncle Sam, the judge, pointing his finger at the labor unions

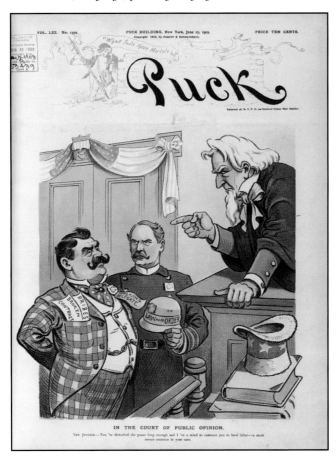

Plate 25

STOP YOUR CRUEL OPPRESSION OF THE JEWS

1904

A message to the Russian Tsar Nicholas II from U.S. President Teddy Roosevelt

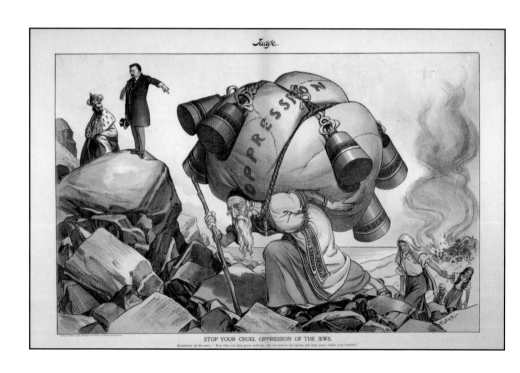

STOP YOUR CRUEL OPPRESSION OF THE JEWS.

Plate 26

JUSTIFIED
1904

Justified in sandbagging his own property because J.P. Morgan said "a man has a right to do what he wants with his own property," referring to anti-trust break-up of Northern Securities Trust, partly formed by Morgan

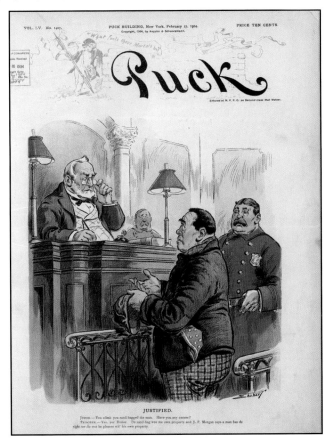

Plate 27

NO DIFFERENCE

1905

The Progressive Movement pushed for police reform to rid the powerful institution of bribery and corruption; "No Difference" refers to similar practices perpetrated with big businesses as well as with small businesses such as in the Tenderloin District, an entertainment and red-light district of New York City.

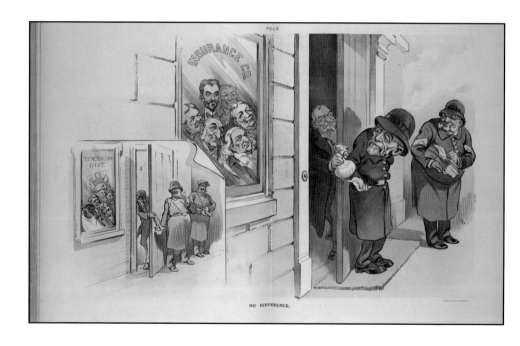

Plate 28

THE ENDLESS GAME

1906

*Chess pieces depict uniformed and plain clothes police as players
in a game of corruption and bribery in New York City.*

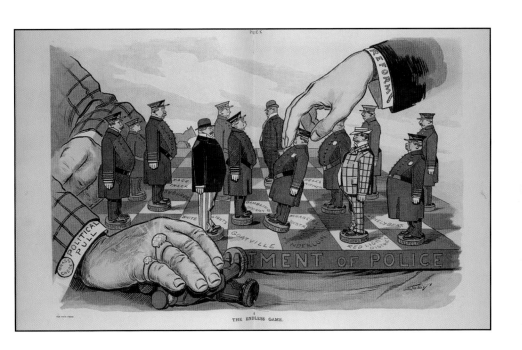

THE ENDLESS GAME.

Plate 29

KEEP OFF THE GRASS
1907
*Anti-trust sentiment: A working class family is kept out of prosperity
by a graft-taking policeman who protects various industrial trusts.*

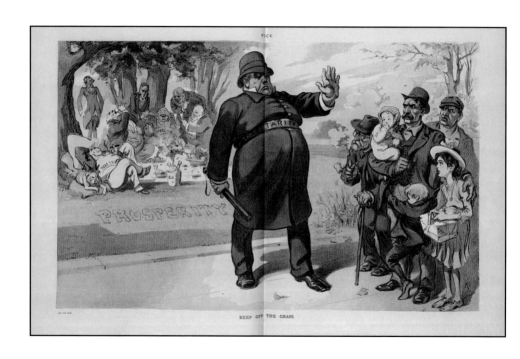

ABOVE THE LAW

1907

*Police have imposed martial law on the laboring class while those responsible
for the deplorable conditions are literally "above the law."*

Plate 30

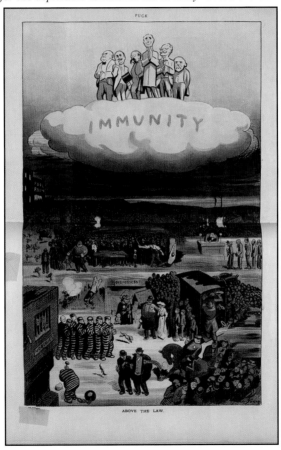

ABOVE THE LAW.

Plate 31

IN THE COMING ERA OF SOCIALISM

1909

Depicts various scenes in the battle between capitalists and socialists.

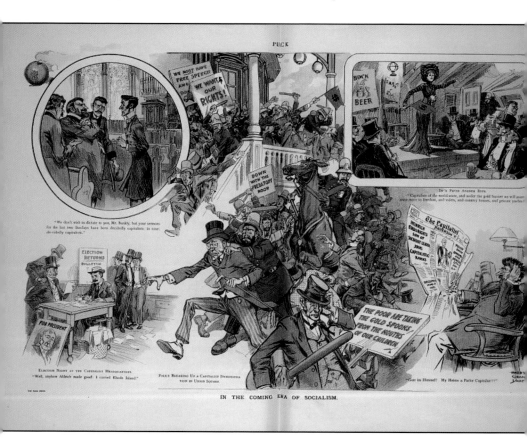

IN THE COMING ERA OF SOCIALISM.

WHICH? FATE OR ECONOMY IN LIFE BOATS

1912

Bemoaning the economic inequalities of passenger deaths on the Titanic

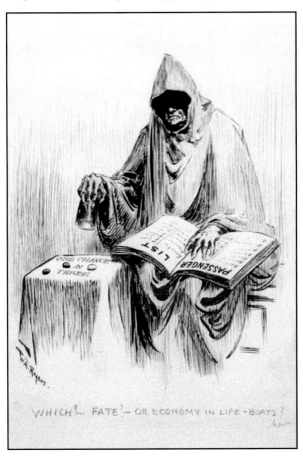

Plate 33

THE HAND THAT SUPPRESSES
c. 1912
Rallying support for child labor reform

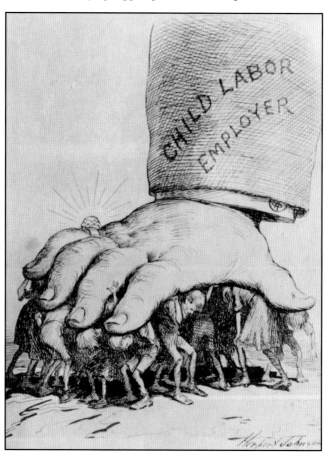

CHILD WORKERS

Plate 34

1912

The State stands idly by as parents weep sending their children to work in the mills.

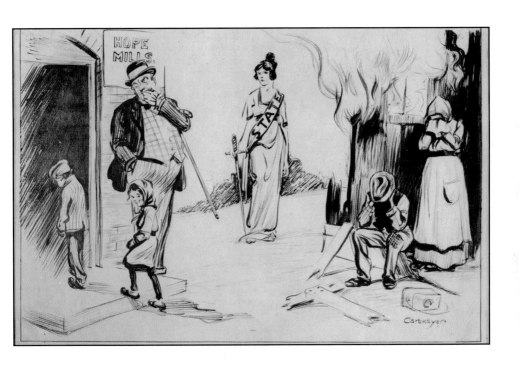

Plate 35

MONROE DOCTRINE

1912

President Taft defended his "Dollar Diplomacy" as an extension of the Monroe Doctrine, a policy introduced in 1823 that stated efforts by European nations to colonize land or interfere with states in North or South America would be viewed as acts of aggression, requiring U.S. intervention.

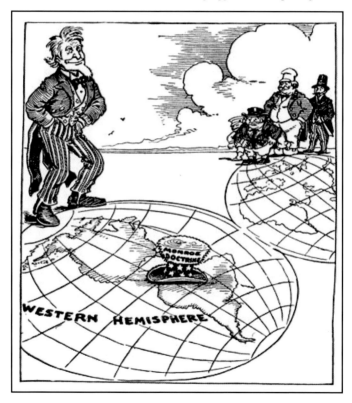

Plate 36

MASHERS

1912

Well-dressed men who oggled and approached women on the street were called mashers. This was a particular problem before women got the vote.

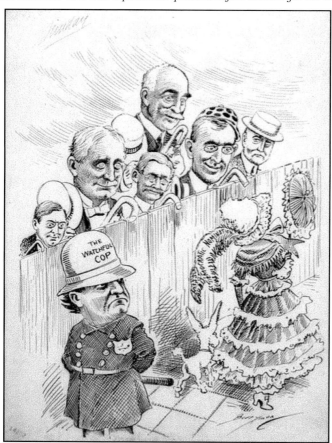

Plate 37

THE SCARLET WOMAN. WHO SHALL SHE PAY?

1913

Prostitution, like most businesses, benefited from police department corruption.

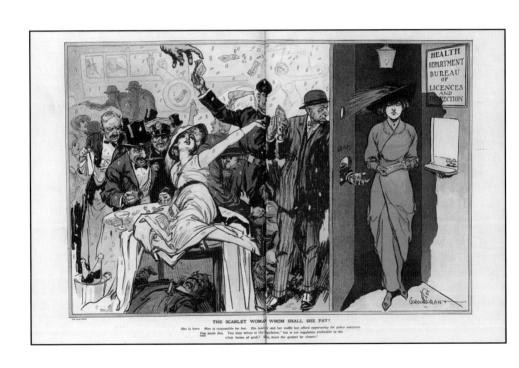

THE SCARLET WOMAN WHOM SHALL SHE PAY?

She is here. Man is responsible for her. His lawyer and her traffic but afford opportunity for police extortion. **You** know this. You may wince at the "regulation," but is not regulation preferable to the vilest forms of graft? Or, must the greater be chosen?

Plate 38

THERE'S A NEW CAPTAIN IN THE DISTRICT

1913

*President Woodrow Wilson as a police officer with William Jennings Bryan,
U.S. Secretary of State, behind him as they walk down a street lined with
corrupt businesses and are spied on by "Flim Flam Finance" and "Tariff Graft"*

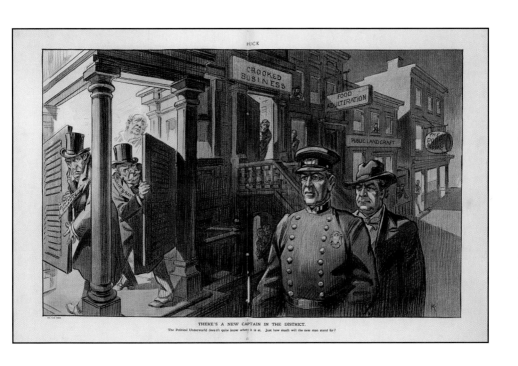

THERE'S A NEW CAPTAIN IN THE DISTRICT.
The Political Underworld doesn't quite know where it is at. Just how much will the new man stand for?

Plate 39

MAKING THE POLLS ATTRACTIVE TO ANTI-SUFFRAGISTS

1915

Society women playing cards and dancing rather than voting; only one woman has taken time away from socializing to cast a ballot into a ballot box brought to her card table.

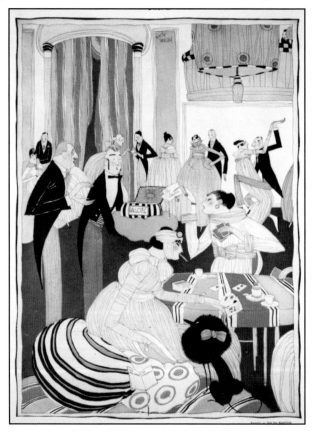

I DID NOT RAISE MY GIRL TO BE A VOTER!

Plate 40

1919

Established institutions of crime and corruption against women getting the vote

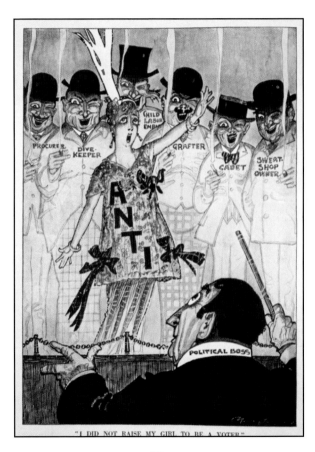

"I DID NOT RAISE MY GIRL TO BE A VOTER."

Plate 41

HUNTING THE HIDDEN TREASURE

1920

*Wealthy industrialists were rumored to have raised millions of dollars to support
the Democratic candidacy of William Gibbs McAdoo for U.S. President.*

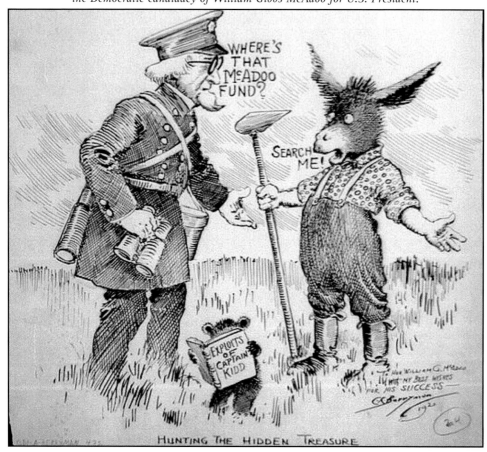

54

POLITICIAN BEFORE AND AFTER ELECTION

Plate 42

1922

Then, as now, the elected official doesn't always remember the wishes of the voters.

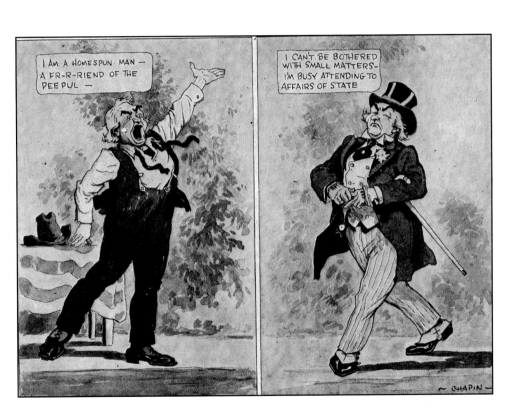

Plate 43

THE DEFENDER OF THE 18TH AMENDMENT

1926

Pro-Prohibition cartoon by the Ku Klux Klan

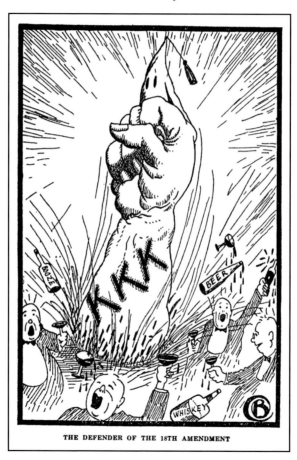

THE DEFENDER OF THE 18TH AMENDMENT

Plate 44

WALL STREET CRASH

1929

Washington, D.C., depicted as an 18th-century colonist because its residents have no vote, and Wall Street bemoaning the problems that have beset them

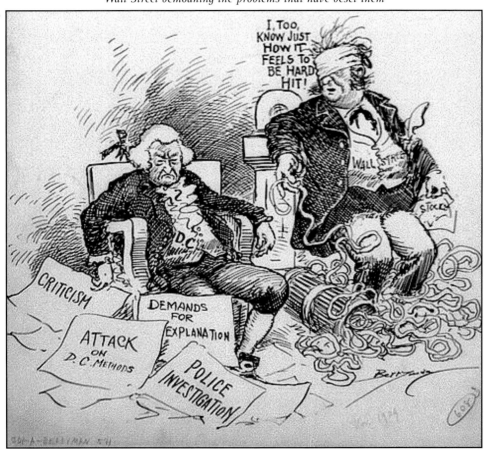

57

Plate 45

THE REAL EMILY POST

1933

Caricature of Emily Post, an American authority on social behavior, relaxing at home. Her private behavior is portrayed as contrary to her public etiquette advice.

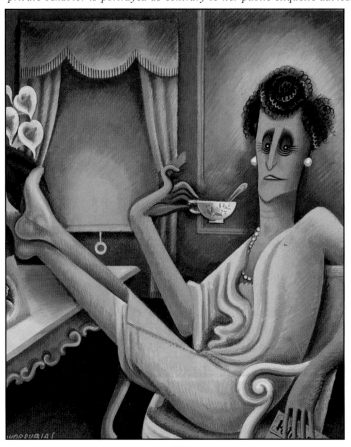

Plate 46

WHAT MAKES YOU THINK I NEED TO BE WARNED?

1940

Pre-WWII wariness of German intentions

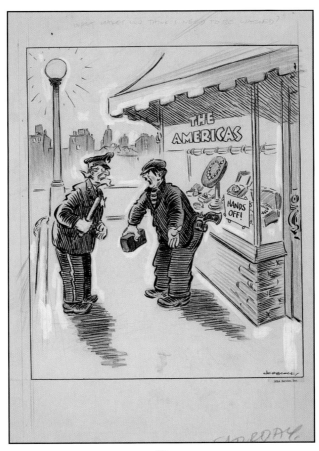

Plate 47

DA NOIVE O' DAT GUY

1940

Mussolini and Hitler are portrayed as gangsters objecting to Uncle Sam protecting himself by walking with a policeman. Refers to criticism of the U.S. rearmament program in 1940 as conflicting with the stated position of the U.S. as a neutral.

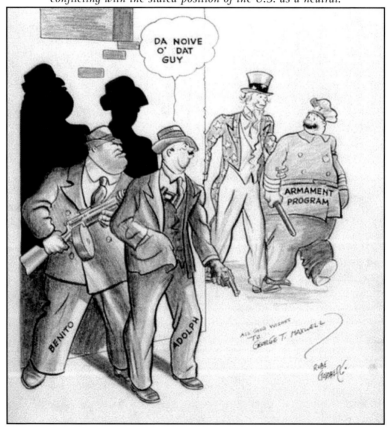

TAKE THAT, JOHN Q. PUBLIC!

1941

Attempt at price controls fails as powerful farm interests pressure House Banking Committee Chairman Henry Steagall into exempting many farm products.

Plate 48

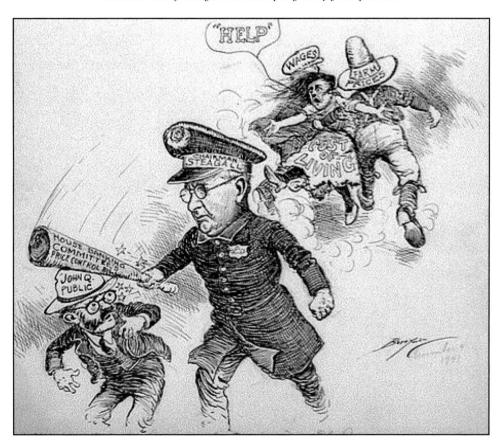

Plate 49

YOU'RE SLIPPING, DR. GOEBBELS!

1942–43

Hitler unhappy with Goebbels' messaging skills for U.S. to end rearmament effort

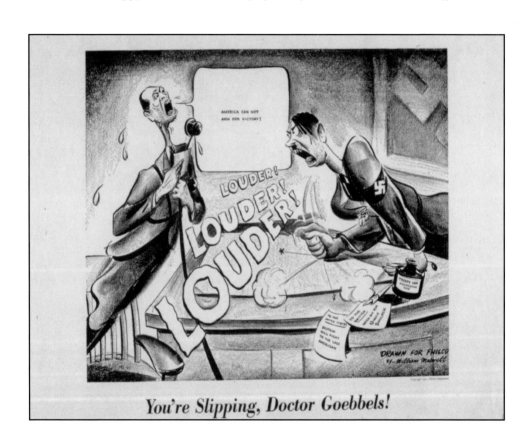

You're Slipping, Doctor Goebbels!

OUTSIDE THE GAS RATION AREA

1942

Rationing viewed as being enforced inequitably

Plate 50

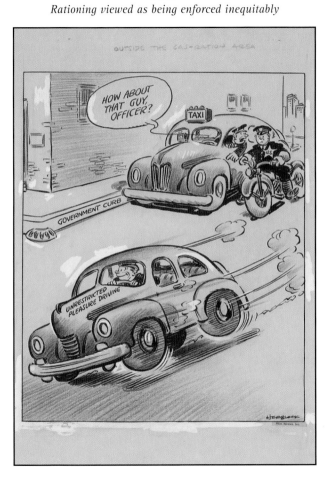

Plate 51

WELL, IT WAS FUN WHILE IT LASTED

1942
Gas rationing in WWII was no fun for anyone.

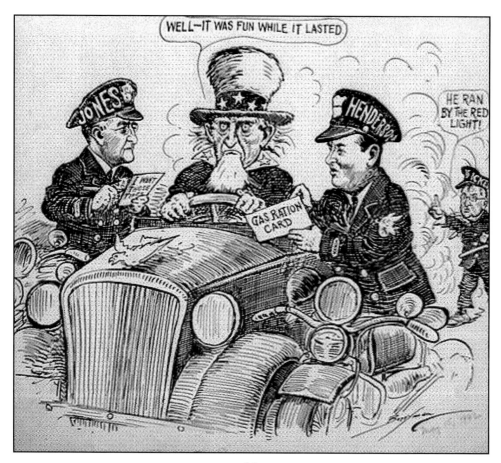

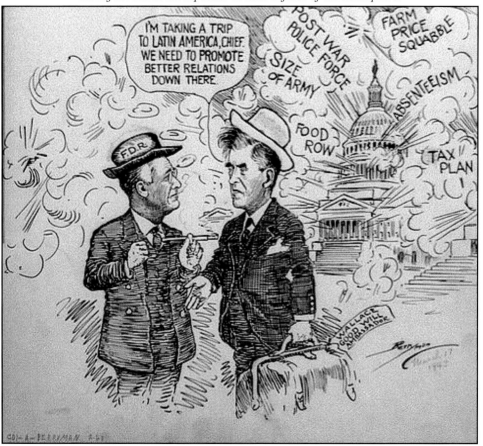

TRIP TO LATIN AMERICA
1943
*Vice President Wallace traveled through South America trying to promote unity
among the American republics in their defense of the hemisphere.*

Plate 52

Plate 53

DON'T STOP TALKING POLITICS

1947

A policeman turning a blind eye to political shennigans

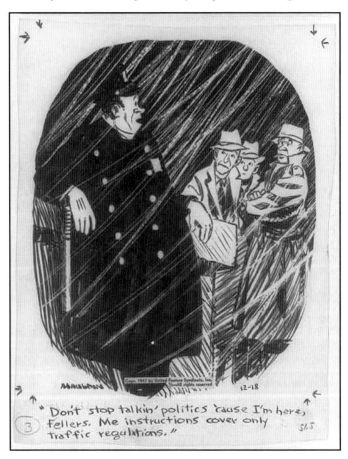

"Don't stop talkin' politics 'cause I'm here, fellers. Me instructions cover only traffic regulations."

Plate 54

WHO WANTS TO LIVE IN A POLICE STATE?

1947

Rising concern over government interference into citizens' lives

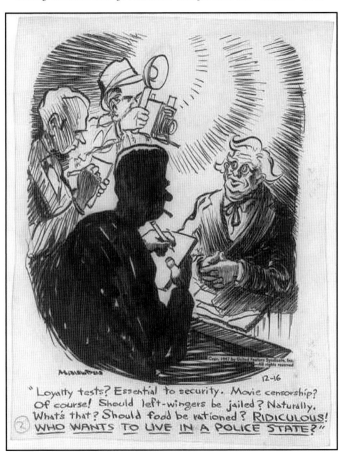

Plate 55

STOP. GO.

1950

John Lewis, president of the United Mine Workers of America, presiding over the coal miners' strikes that plagued the nation for nine months in 1949–1950

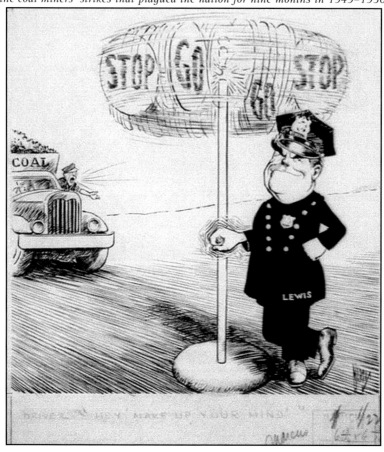

NO MONKEY WRENCHES ALLOWED

Plate 56

1951

Soviet Foreign Minister Andrei Gromyko attempts to stall the Treaty of Peace with Japan.

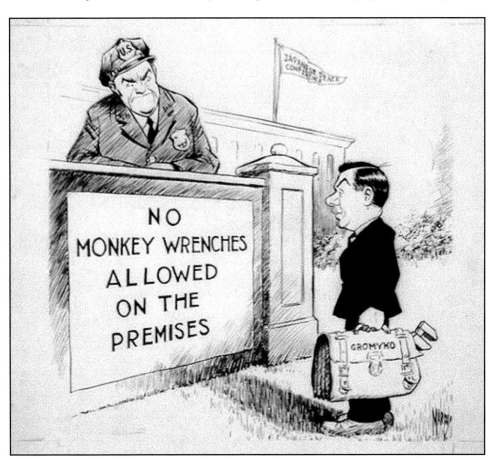

Plate 57

DARK LAUGHTER
1960
"The teacher says everyone can git to be President."

DEPENDS ON HOW YOU LOOK AT IT

Plate 58

1961

The state of the Union as viewed differently by Republicans and Democrats

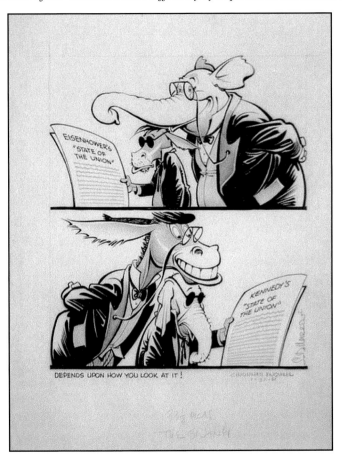

Plate 59

YOU'RE NEW HERE, AREN'T YOU?

1961

The communist state's fear of its own people desiring to flee to the West

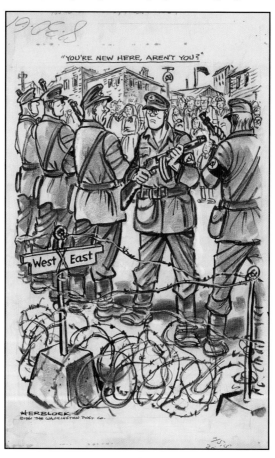

ROLE REVERSAL

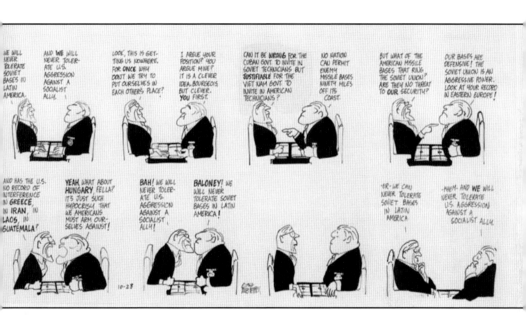

1962

A member of President Kennedy's administration and a representative of the Soviet Union becoming absorbed in each other's argument

Plate 60

Plate 61

JOHN F. KENNEDY

1963
Discussing his popularity with an aide

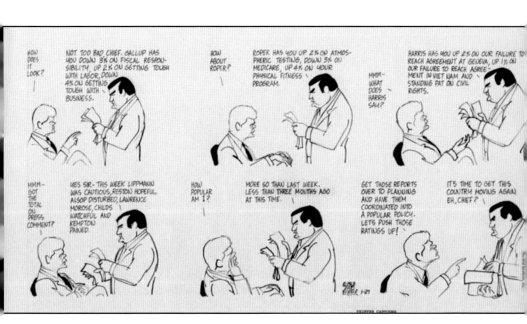

Plate 62

SELMA, ALABAMA

1965

Portraying a view that Southern whites were prejudiced, and worse

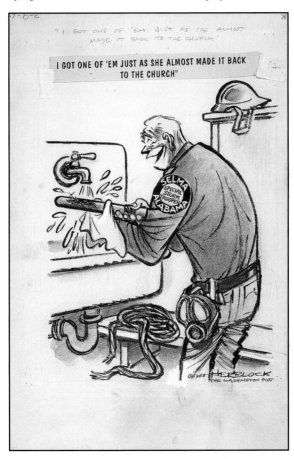

GEORGE WALLACE AT WORK
1965
Wallace's control over the "apes" enforcing Alabama's school segregation laws

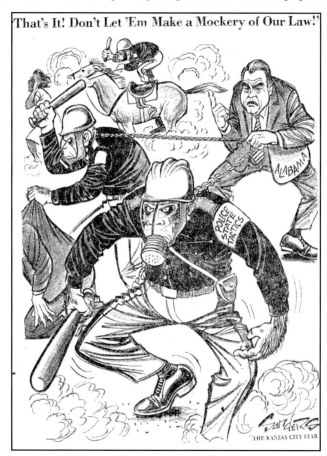

1966

A budget cut by the Johnson administration is dwarfed by a backpocket tax increase.

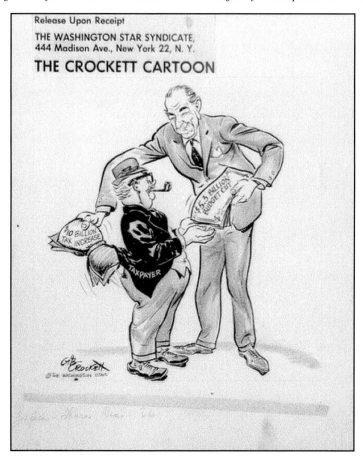

Plate 65

LYNDON JOHNSON AND RICHARD NIXON

1968

Richard Nixon assuming the presidency from Lyndon Johnson

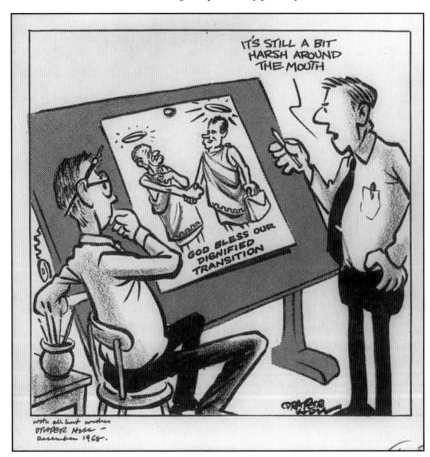

DWIGHT D. EISENHOWER

1969

In memory of President Eisenhower and his values at the time of his death, March 1969

Plate 66

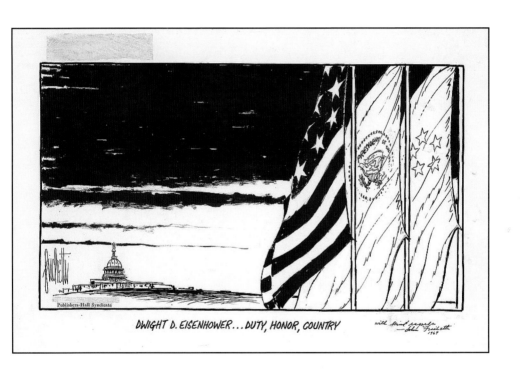

DWIGHT D. EISENHOWER...DUTY, HONOR, COUNTRY

Publishers-Hall Syndicate

with kind regards
—John Fischetti
1969

Plate 67

MY DANCE TO SUMMER

1968

Fading commitment of "faddish" Vietnam war protesters in summer 1968

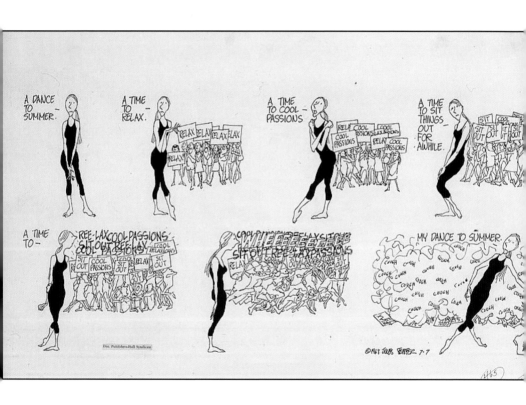

ANTI-PRIVACY

1970

Lamenting U.S. citizens' loss of privacy at the hands of their government

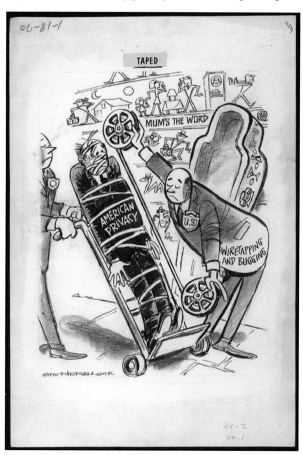

Plate 69

OPEN ADMINISTRATION
1970
Mocking the Nixon administration's crackdown on press and personal freedoms

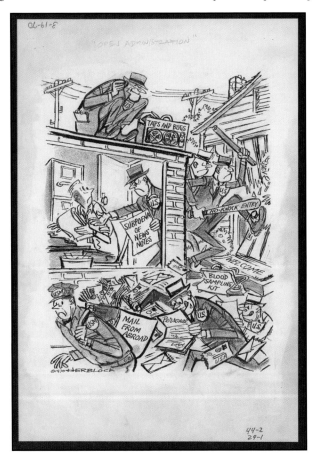

Plate 70

1971

Nixon and Agnew's interference with broadcasters who own newspapers

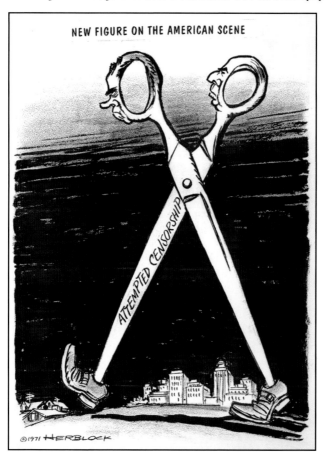

Plate 71

20,000 AMERICANS DEAD SINCE 1968

1972

Nixon fails to bring troups home as promised in his first election pledge

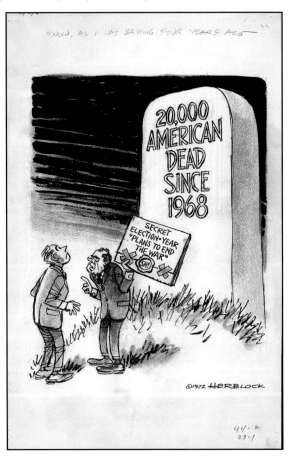

Plate 72

WATERGATE
1973
Nixon engulfed in Watergate scandal

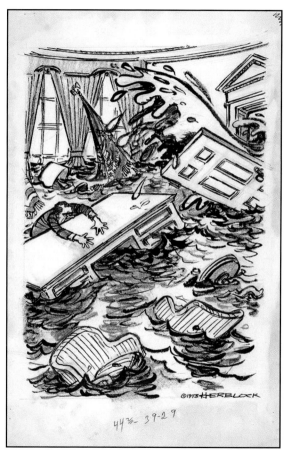

Plate 73

NIXON TAPES

1974

Nixon ordered by the Supreme Court to hand over White House tapes

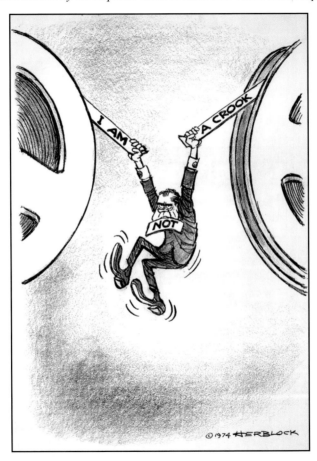



Plate 74

NIXON ALONE

1974

Watergate-related convictions leave Nixon to contemplate resignation.

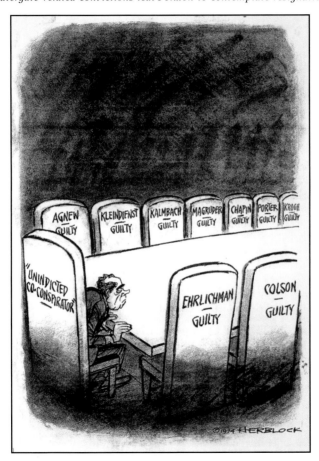

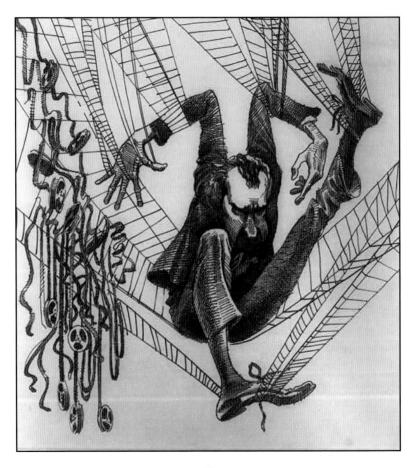

Plate 75

NIXON CAUGHT IN A WEB

1974

Nixon dangles in a spider's web with the recording tapes that implicated him in the Watergate scandal.

WAYS AND MEANS

1974

Demise of Congressman Wilbur Mills' career after being stopped for drunk driving;
his stripper mistress, Fanne Foxe, jumped into the Tidal Basin in an attempt to escape.

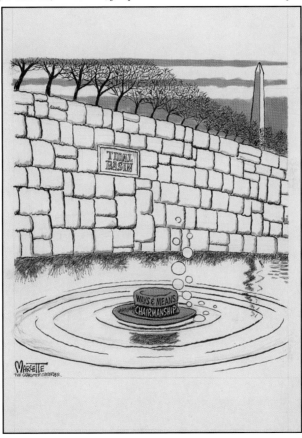

Plate 76

Plate 77

JIMMY CARTER AND THE LOBBYISTS
1976
Lobbyists "thanking" Jimmy Carter for not limiting their access to politicians

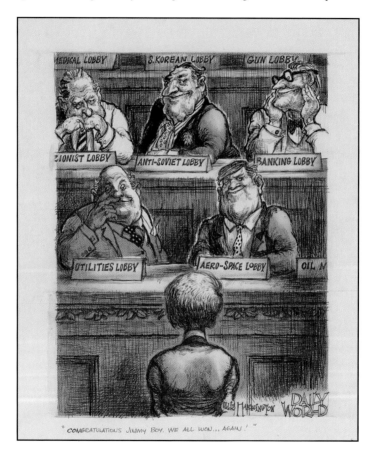

THERE HE GOES AGAIN

Plate 78

1984
Ronald Reagan's ease in escaping responsiblity for
issues prominent in the 1984 presidential election

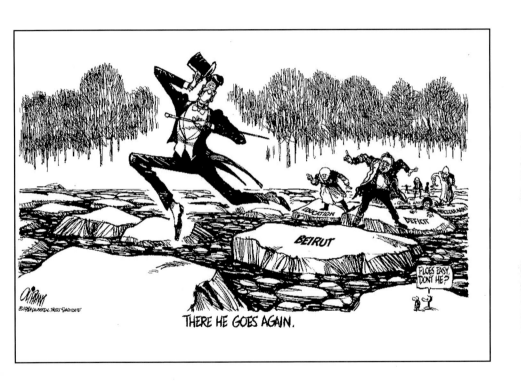

THERE HE GOES AGAIN.

Plate 79

BALANCE

1996

Bill Clinton's well-known agility in balancing politics and the ladies

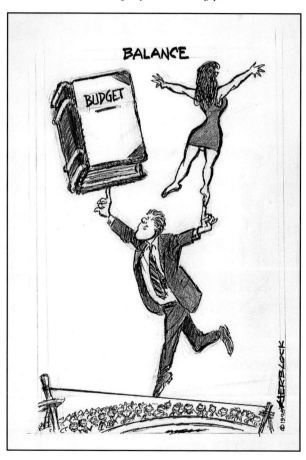

I DIDN'T SWALLOW

Plate 80

1997

Bill Clinton's penchant for denying obvious responsibility

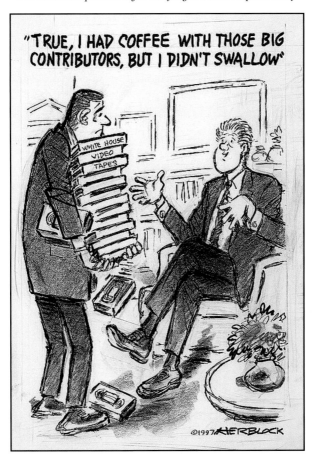

Plate 81

PUT THIS ON!

2000

Supreme Court rules in favor of local government regulation of strippers

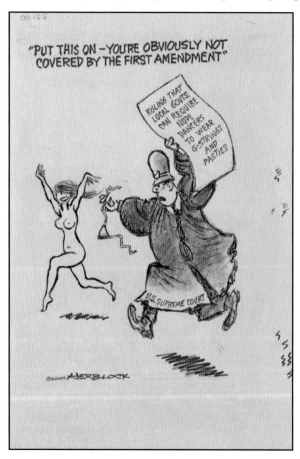

RUSH LIMBAUGH

2009

The "ugly" face of the GOP

Plate 82

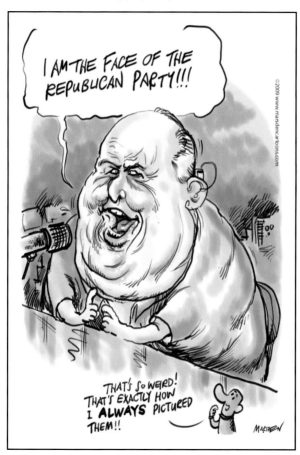

INDEX

20,000 Americans Dead Since 1968	84
A Heavy Hand	31
A Needed Change in the Senatorial Lobby	36
A New Year	30
Above the Law	43
Andrew Johnson and Abraham Lincoln	15
Anti-Privacy	81
Attacking Him in Broad Daylight	28
Balance	92
Broken Banks—Who Is Responsible?	19
Bursting the Balloon	14
Busted	20
Child Workers	47
D.C., I've Got Some Houscleaning to Do	29
Da Noive o' Dat Guy	60
Dark Laughter	70
Depends on How You Look at It	71
Don't Stop Talking Politics	66
Dwight D. Eisenhower	79
Fight for a Sensible Sunday Law	34
George Wallace at Work	76
Have a Beer, Neighbor	17
Hunting the Hidden Treasure	54
Hush Money	21
I Did Not Raise My Girl to Be a Voter!	53
I Didn't Swallow	93
In the Coming Era of Socialism	44
In the Court of Public Opinion	37
Jimmy Carter and the Lobbyists	90
John F. Kennedy	74
Justified	39
Keep Off the Grass	42
Lyndon Johnson and Richard Nixon	78
Making the Polls Attractive to Anti-Suffragists	52
Mashers	49
Mayor Abram Hewitt	24
Monroe Doctrine	48
Mulberry Ring Growing Fat	26
My Dance to Summer	80
New Figure on the American Scene	83
New Kind of Policy Shop	25
Nixon Alone	87
Nixon Caught in a Web	88
Nixon Tapes	86
No Difference	40
No Monkey Wrenches Allowed	69
Noise or Nothing!	22
Nursery Rhymes for Infant Industries	35
Open Administration	82
Outside the Gas Ration Area	63
Politician Before and After Election	55
President Andrew Johnson's Ambitions	16
President Garfield's Inauguration	18
President Lyndon Johnson and Taxpayer	77
Put This On!	94
Role Reversal	73
Rush Limbaugh	95
Selma, Alabama	75
Stop Your Cruel Oppression of the Jews	38
Stop. Go.	68
Take That, John Q. Public!	61
The Defender of the 18th Amendment	56
The Endless Game	41
The Hand That Suppresses	46
The Mote in Our Neighbor's Eye	32
The Real Emily Post	58
The Scarlet Woman. Who Shall She Pay?	50
The Wheel That Can't Be Stopped: Human Nature	33
There He Goes Again	91
There's a New Captain in the District	51
To Begin With, I'll Paint the Town Red	23
Trip to Latin America	65
Wall Street Crash	57
Wangtown Bugle	27
Watergate	85
Ways and Means	89
Well, It Was Fun While It Lasted	64
What Makes You Think I Need to Be Warned?	59
Which? Fate or Economy in Life Boats	45
Who Wants to Live in a Police State?	67
You're New Here Aren't You?	72
You're Slipping, Dr. Goebbels!	62